LIFE LESSONS
FROM
DINOSAURS

LIFE LESSONS
FROM
DINOSAURS

JAMES GURNEY

Andrews McMeel
PUBLISHING®

Dinosaurs survived on Earth for far longer than we humans have been here. So maybe we can learn something from them.

That's what happens in Dinotopia, where humans and dinosaurs have formed a civilization together.

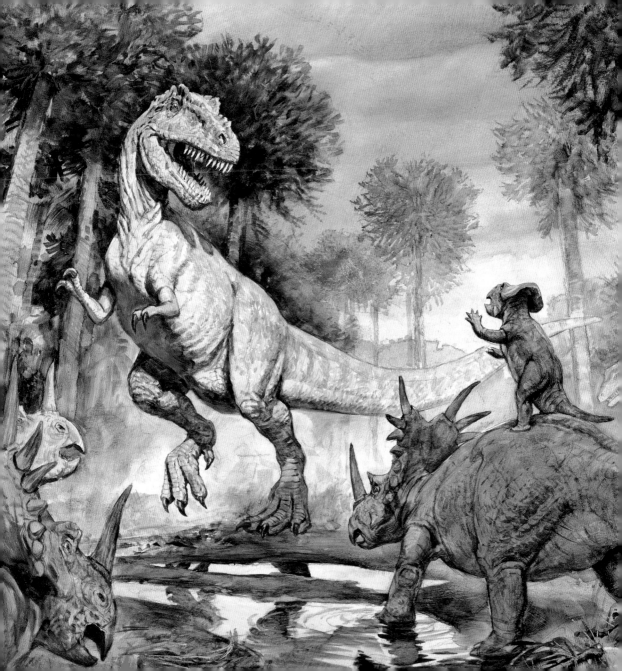

SHAKE
THE
GROUND
A LITTLE.

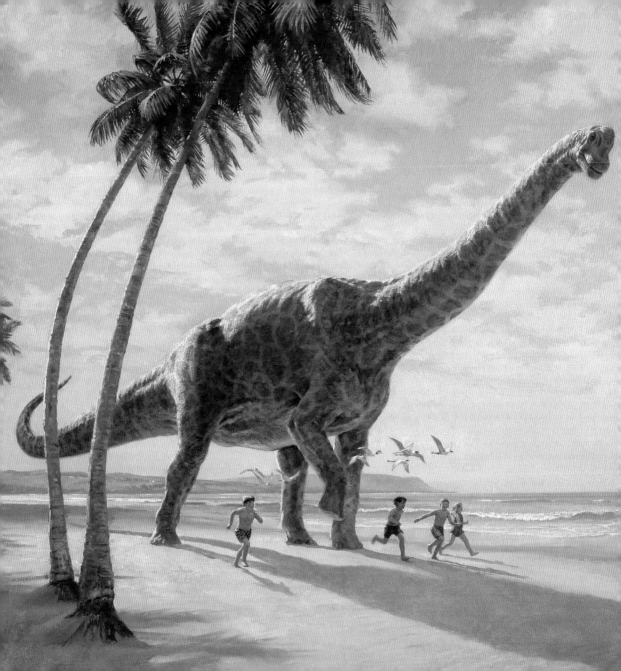

TREAD
CAREFULLY
WHEN THERE ARE
LITTLE ONES
AROUND.

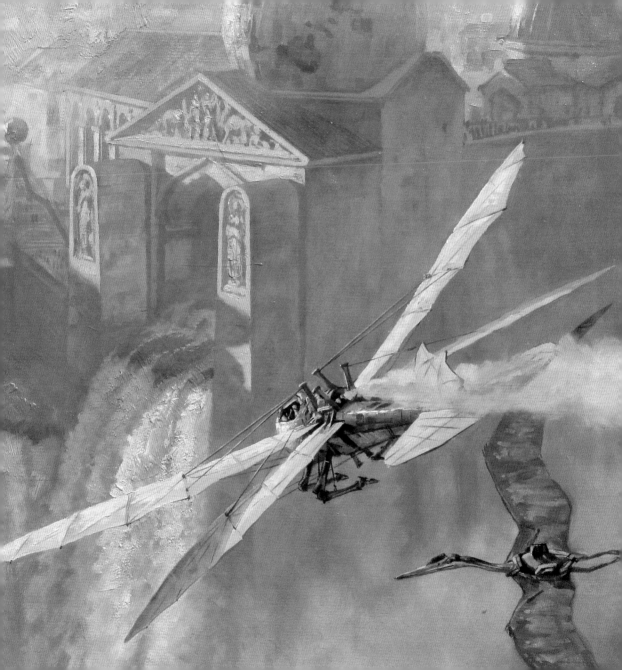

IF ALL ELSE FAILS, IMPROVISE.

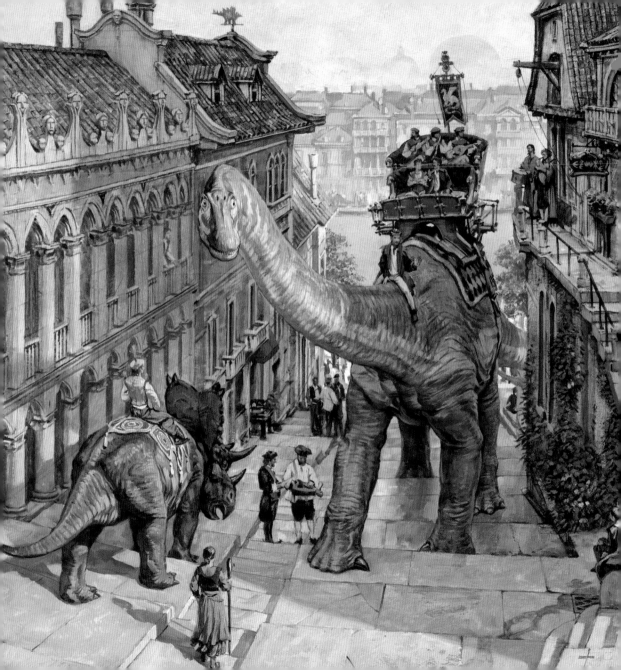

IF YOU HAVE A
SMALL BRAIN,
MAKE SURE YOU HAVE A
BIG HEART.

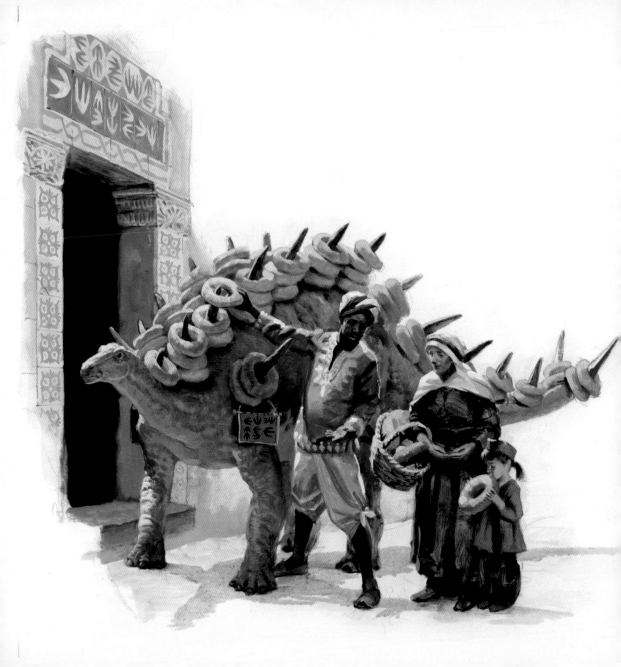

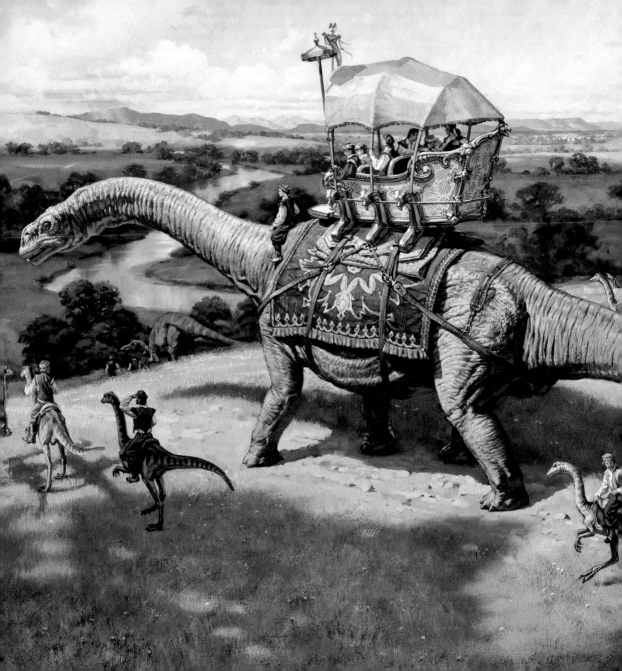

REALITY
IS FOR PEOPLE WHO CAN'T DEAL WITH
FANTASY.

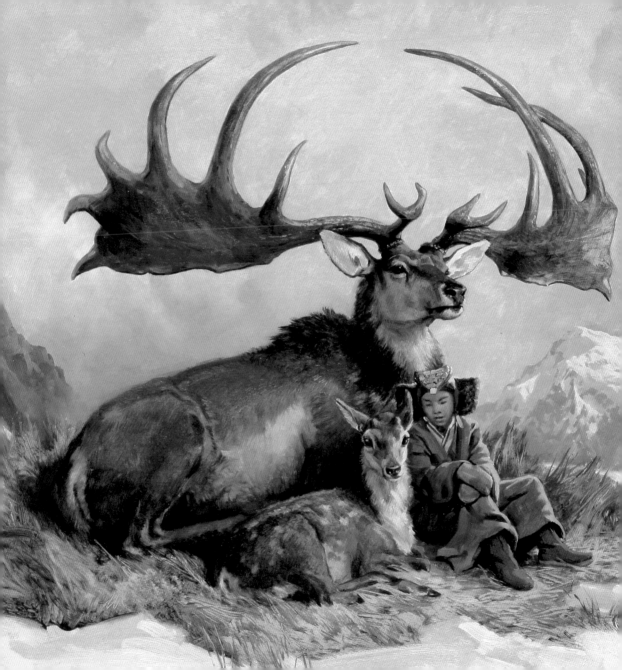

YOU'RE NOT
OLD,
YOU'RE JUST
HIGHLY EVOLVED.

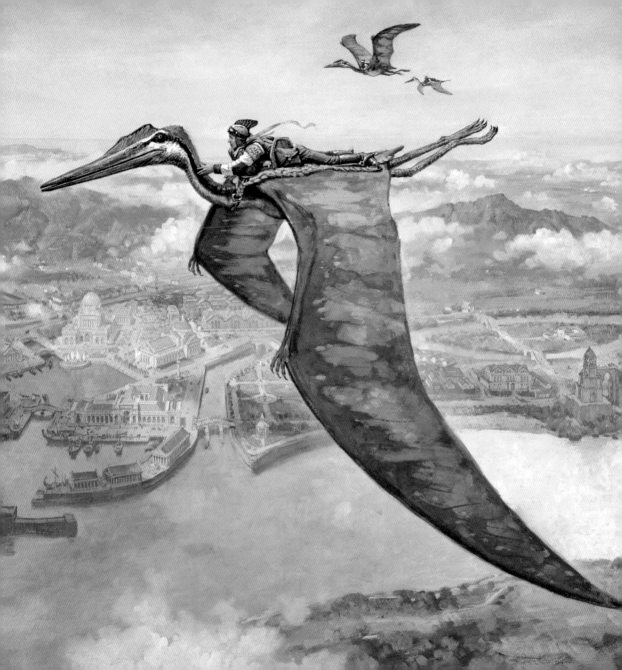

RESIST
GRAVITY
AND
INERTIA.

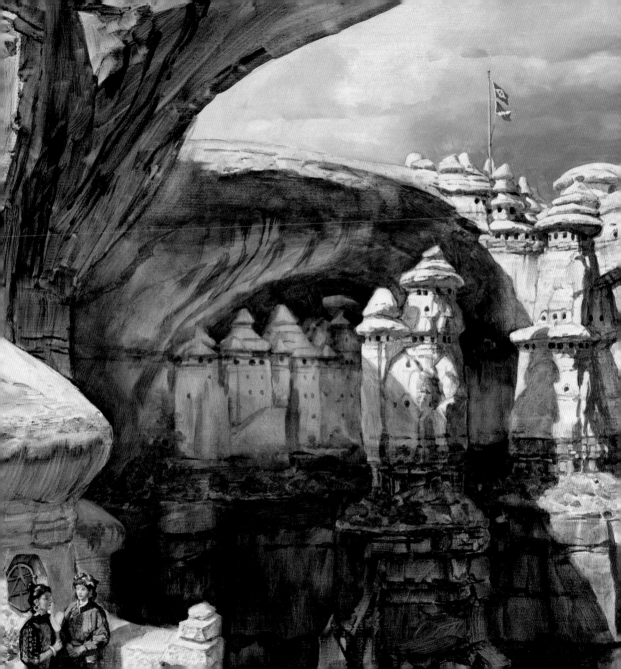

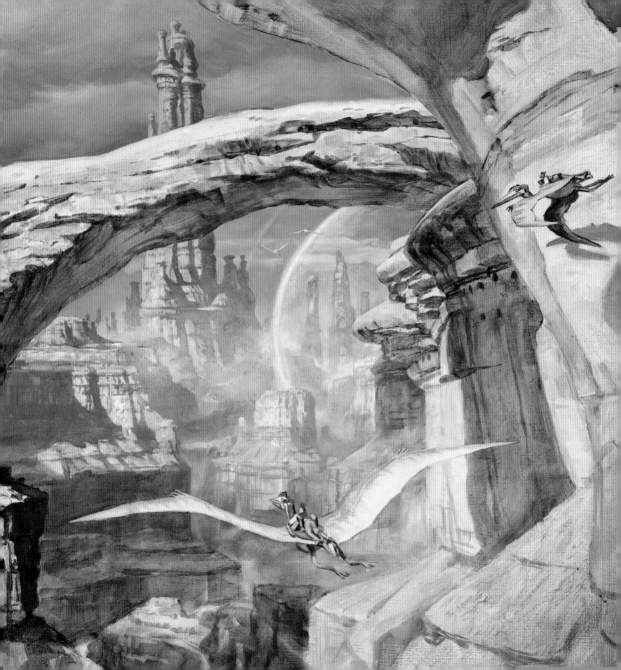

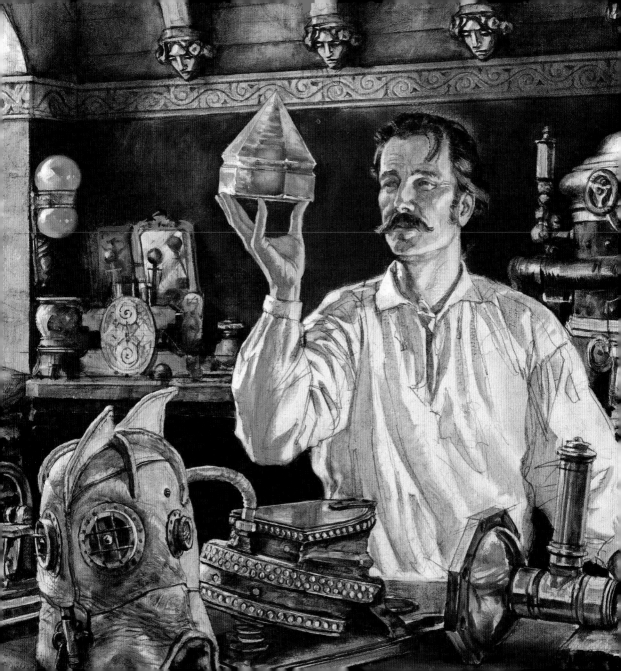

CULTIVATE
ENLIGHTENMENT.

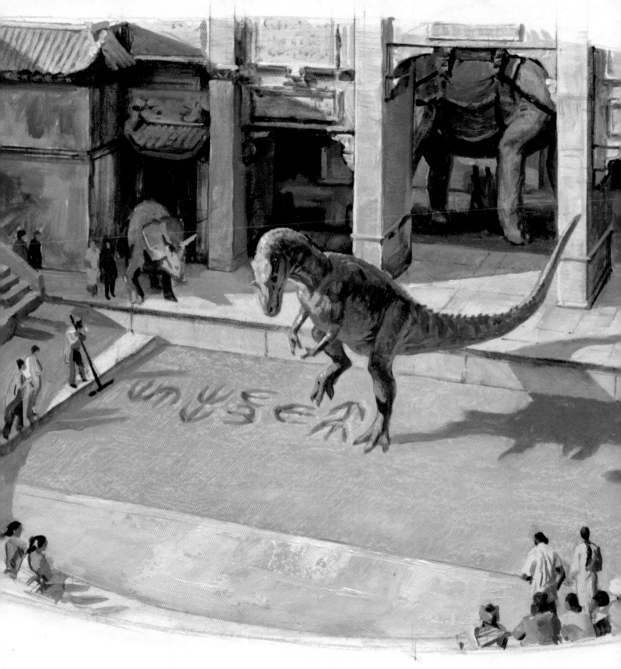

LEAVE
INTERESTING
TRACKS
FOR THOSE WHO
FOLLOW AFTER.

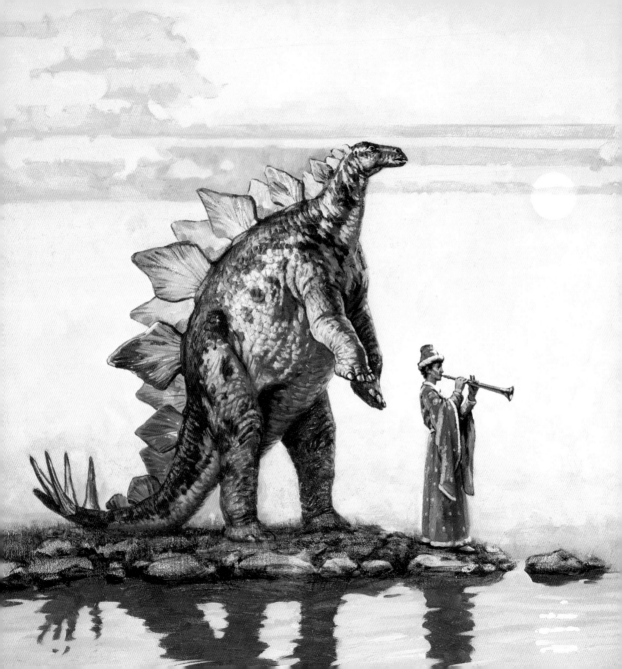

THE MOST
BEAUTIFUL
VISIONS
OF NATURE
ARE FLEETING.

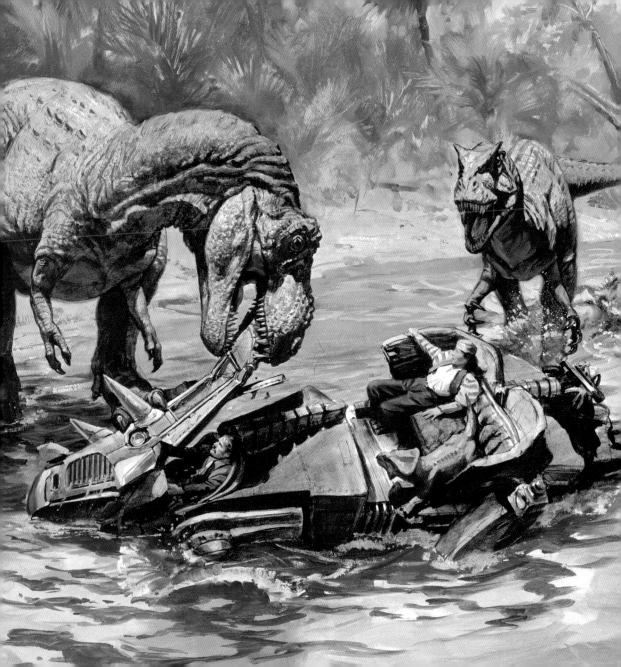

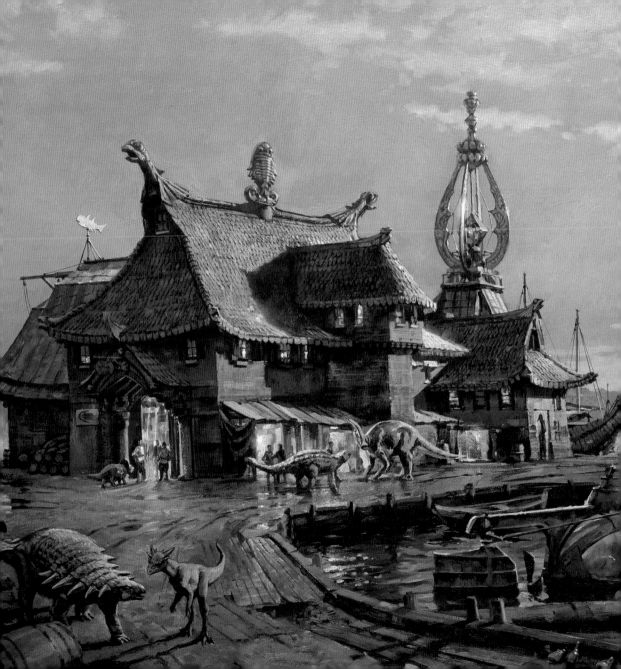

STEER CLEAR OF
TAR PITS.

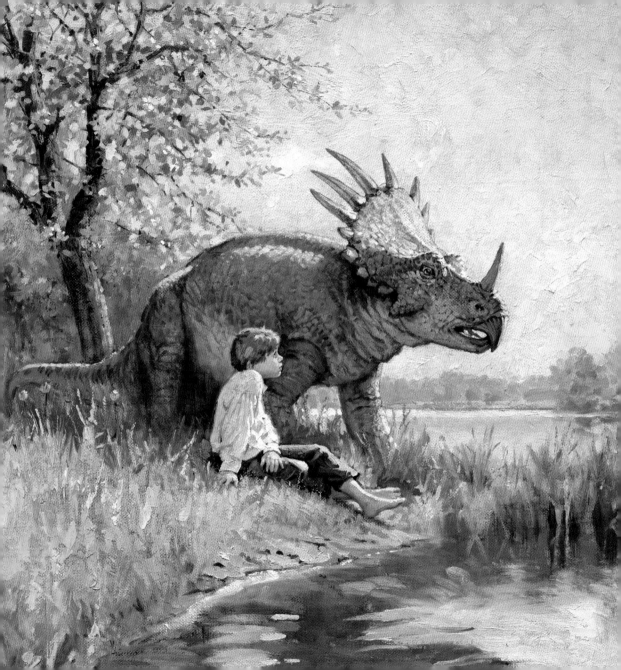

BEST FRIENDS
REVEL IN THEIR
DIFFERENCES.

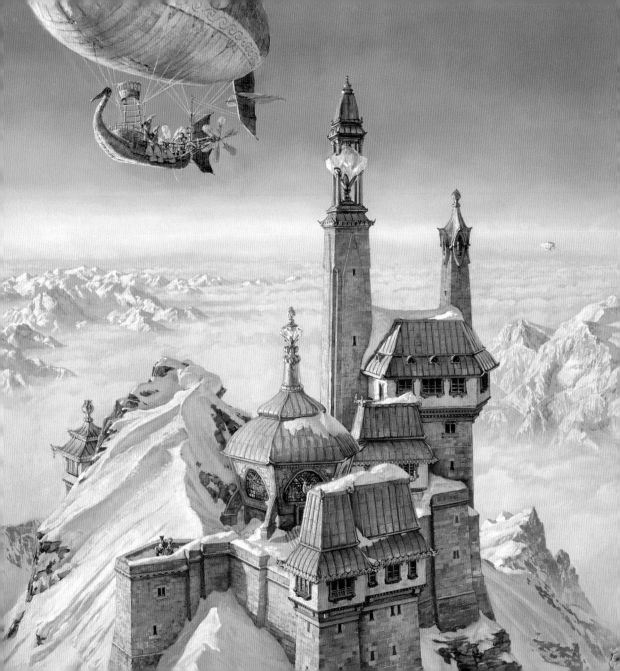

THINK
LOFTY
THOUGHTS.

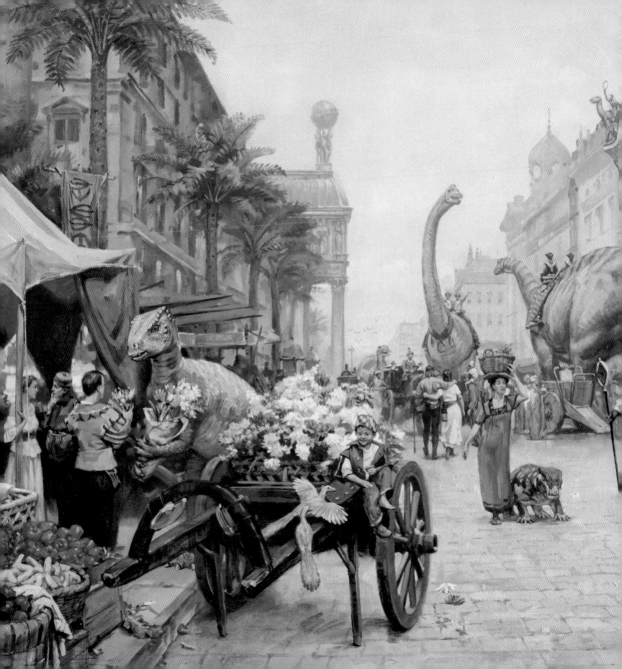

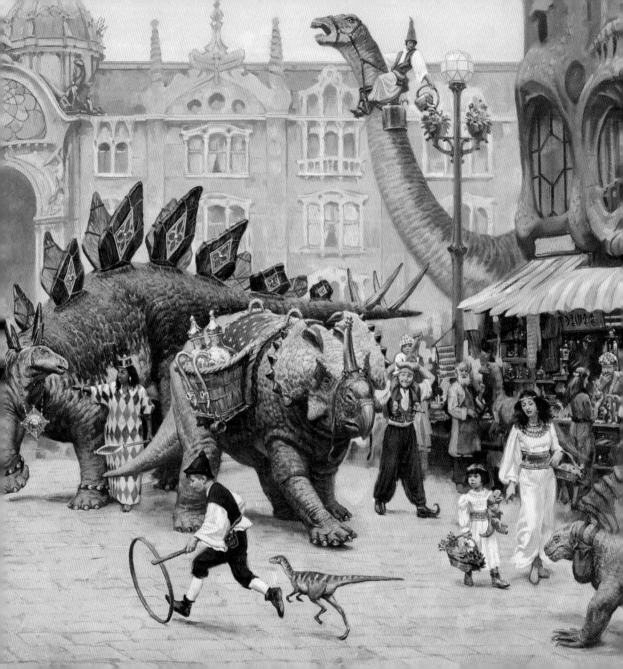

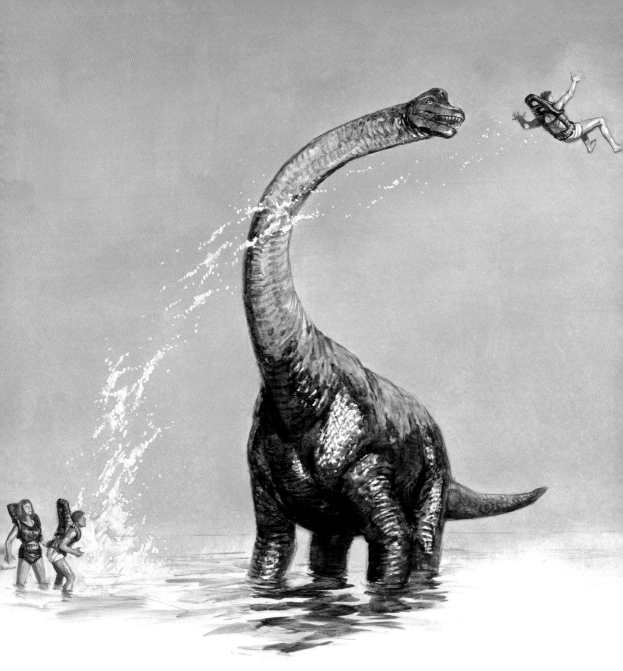

LET A FRIEND
LIFT YOU UP.

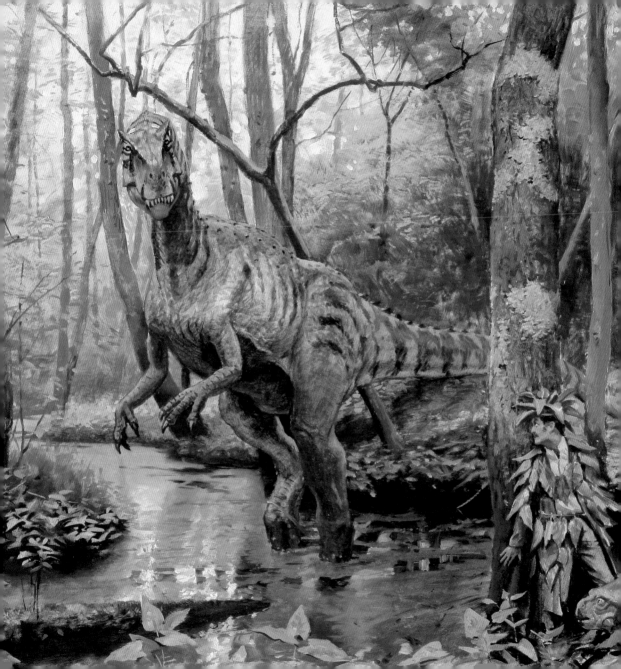

WE ARE ALL INVASIVE SPECIES.

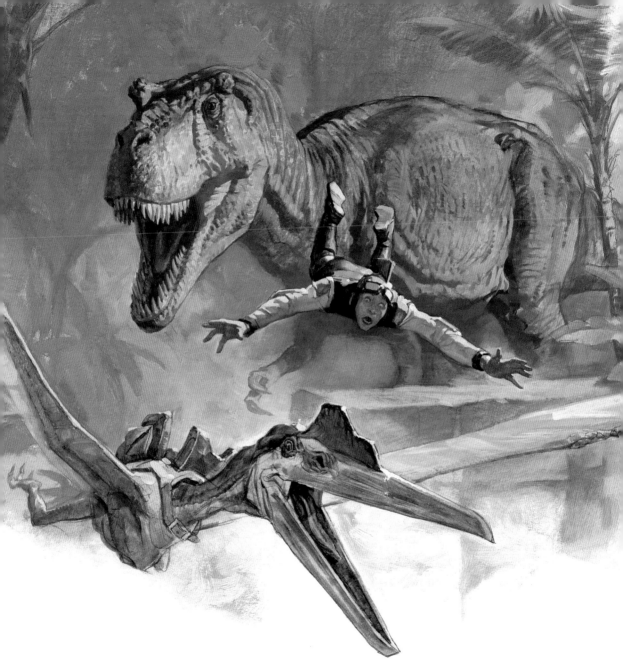

BE
FEARLESS
BUT
PREPARED.

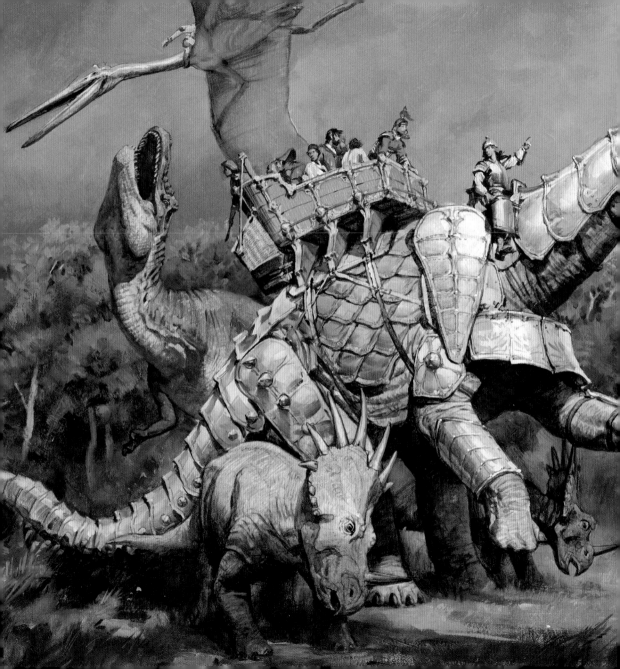

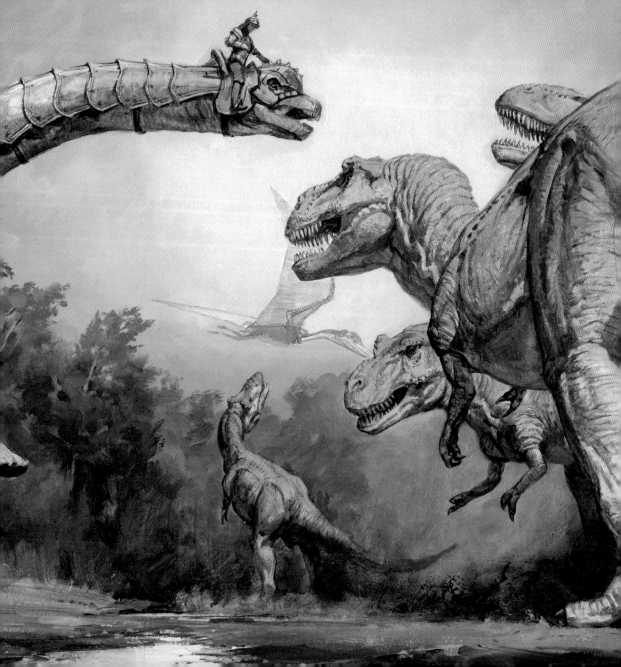

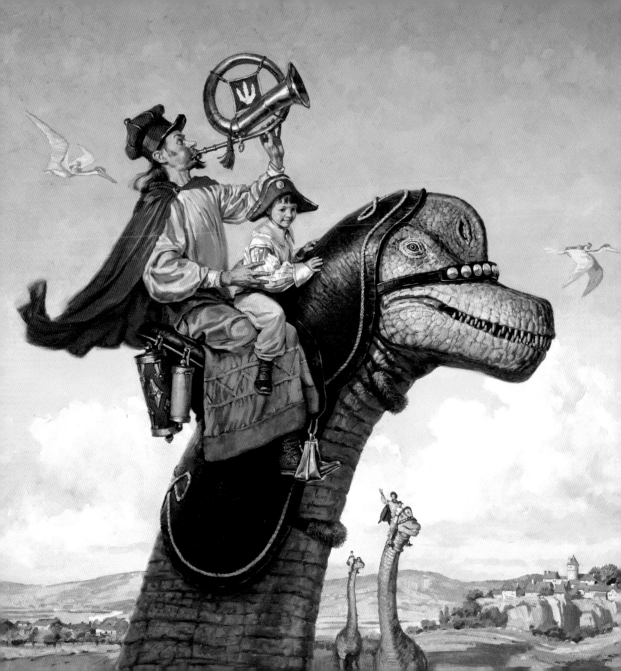

RAISE YOUR GAZE
TO TAKE IN THE
BIG VIEW.

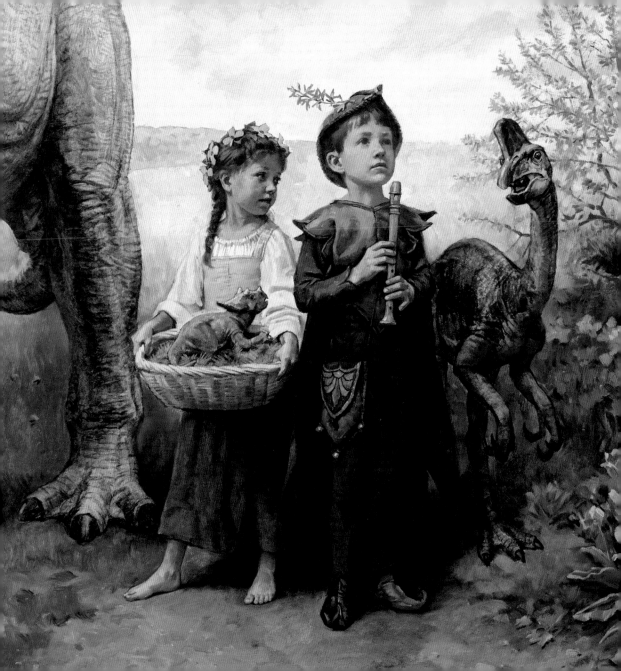

ENJOY THE
MOMENT,

BUT LIVE FOR
THE AGES.

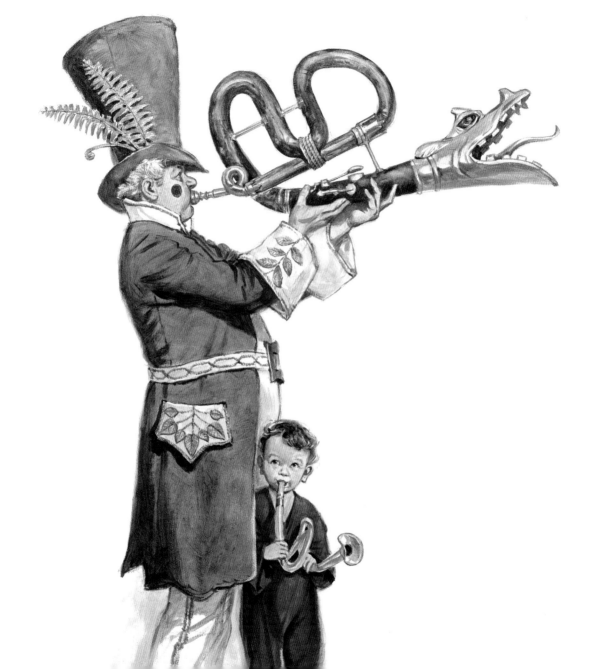

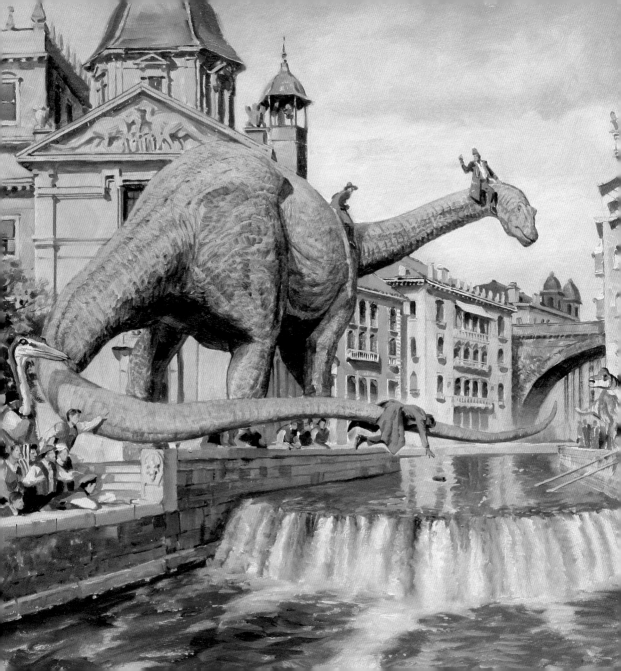

THERE'S ALWAYS TIME TO HELP SOMEONE IN NEED.

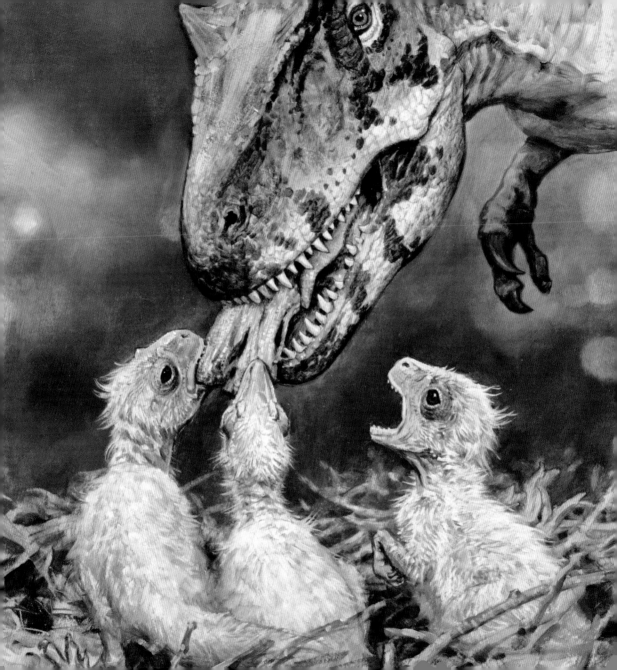

YOU'RE NOT
JUST A BIRD.
YOU'RE A COUSIN
OF T. REX.

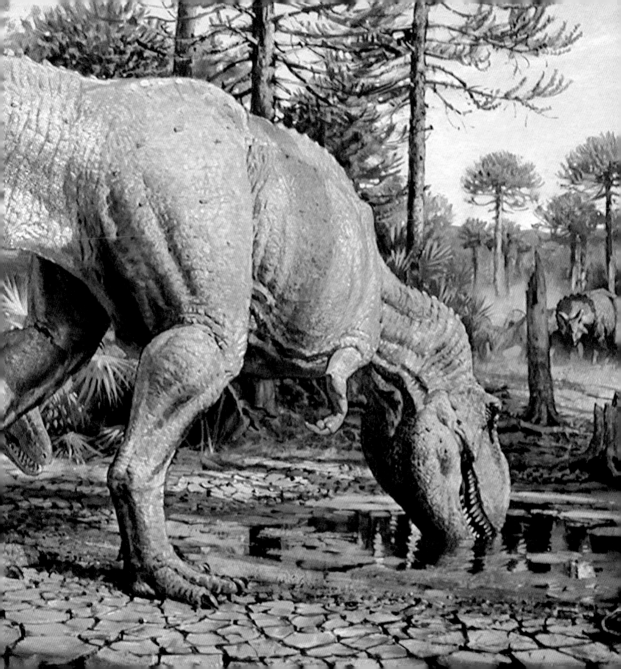

WATCH OUT
FOR
ASTEROIDS.

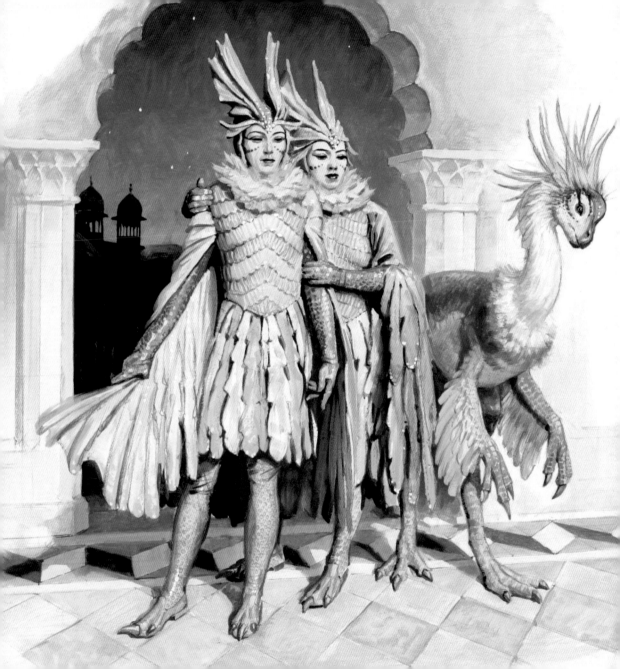

GROW MORE
FEATHERS
INSTEAD OF
SPIKES.

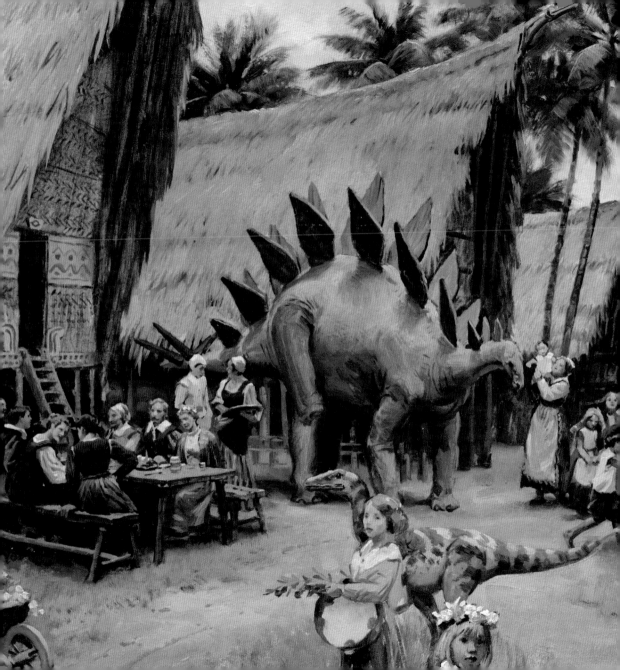

FROM
EGG TO EXIT,
IT'S ALL
ABOUT CHANGE.

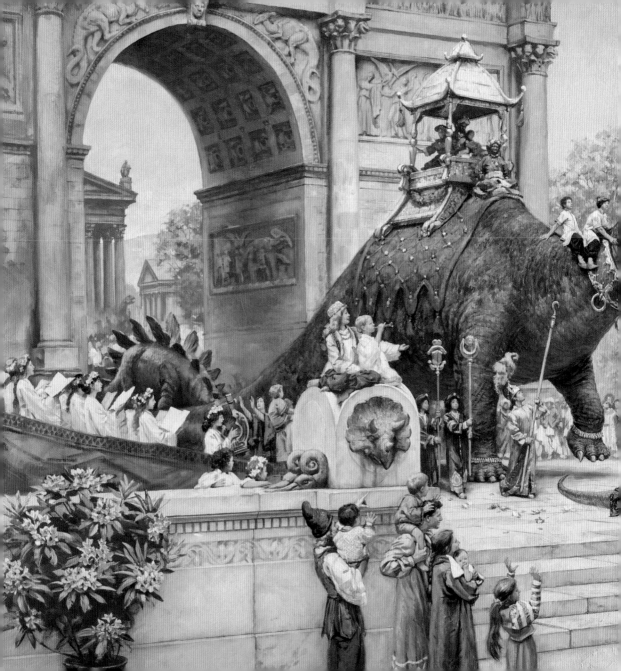

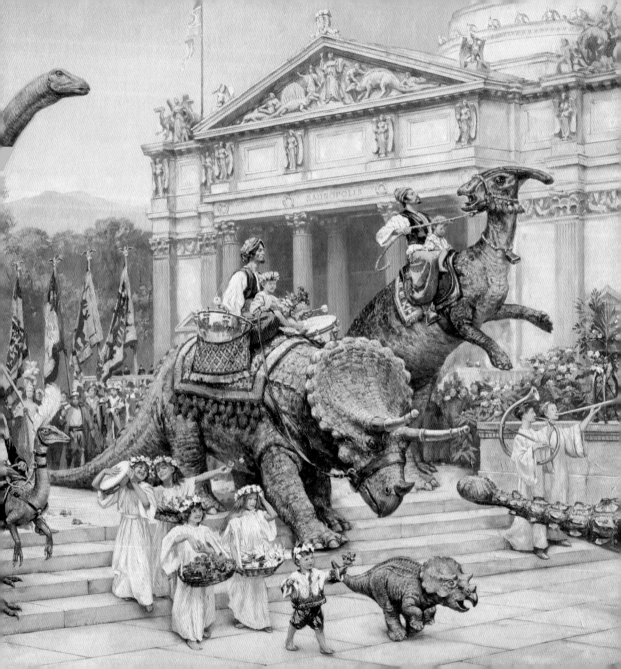

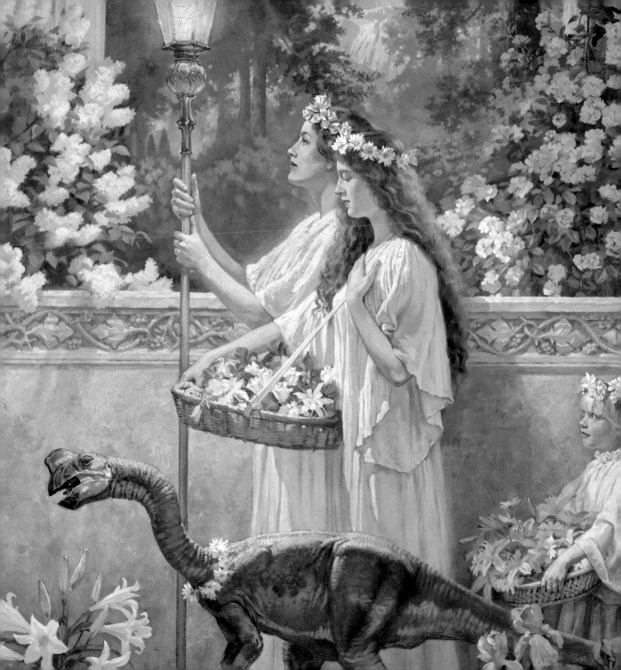

THINK WITH
YOUR HEART.

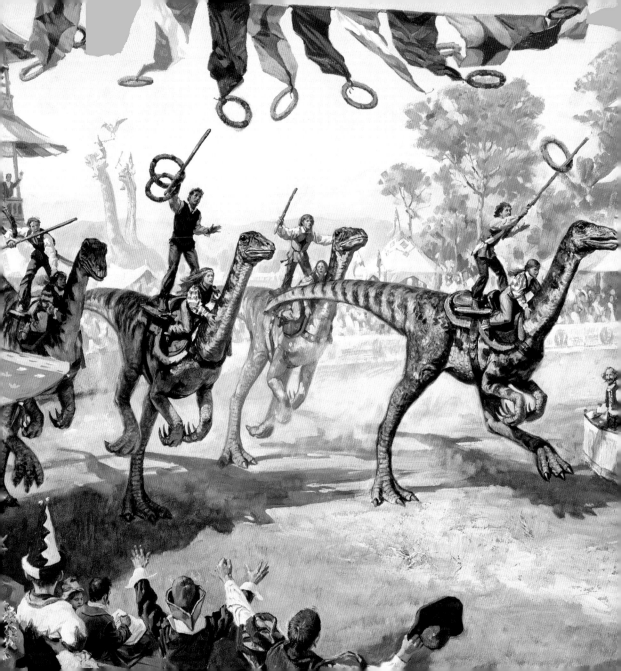

EVERYTHING BEGINS WITH WHAT YOU IMAGINE.

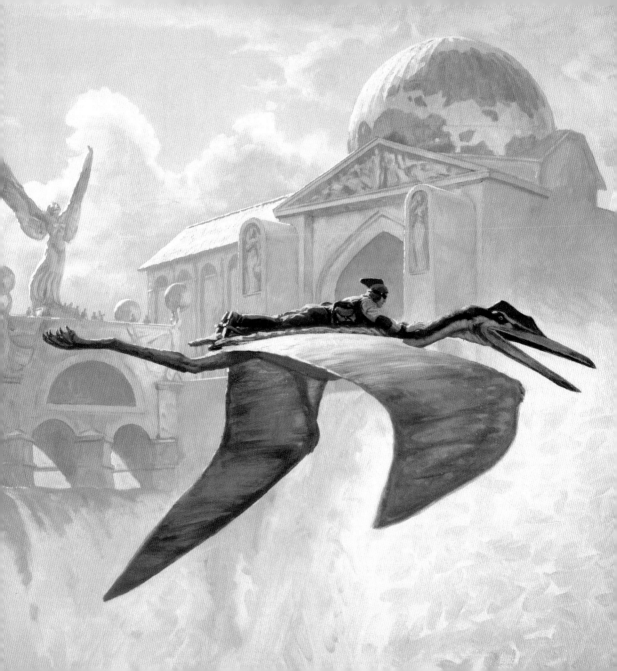

FLY HIGH
ABOVE LITTLE
WORRIES.

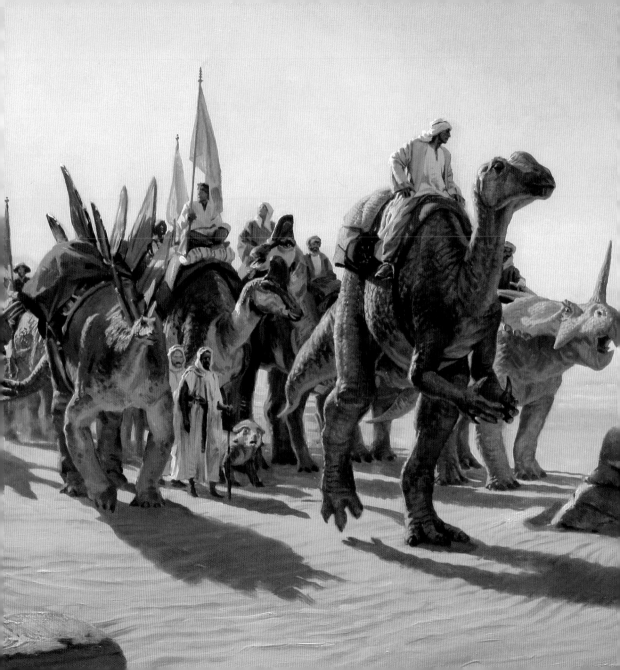

DON'T
FOSSILIZE.

KEEP
EVOLVING.

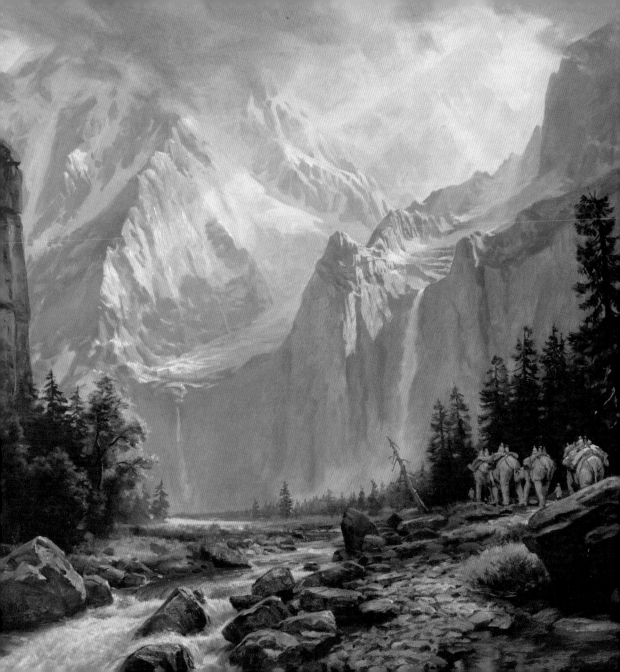

BE PATIENT.
VALLEYS
REBOUND INTO
MOUNTAINS.

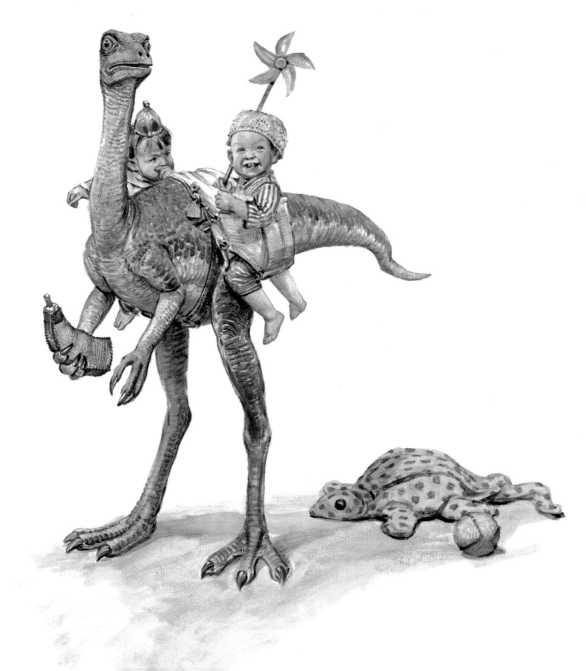

SURROUND YOURSELF WITH HATCHLINGS.

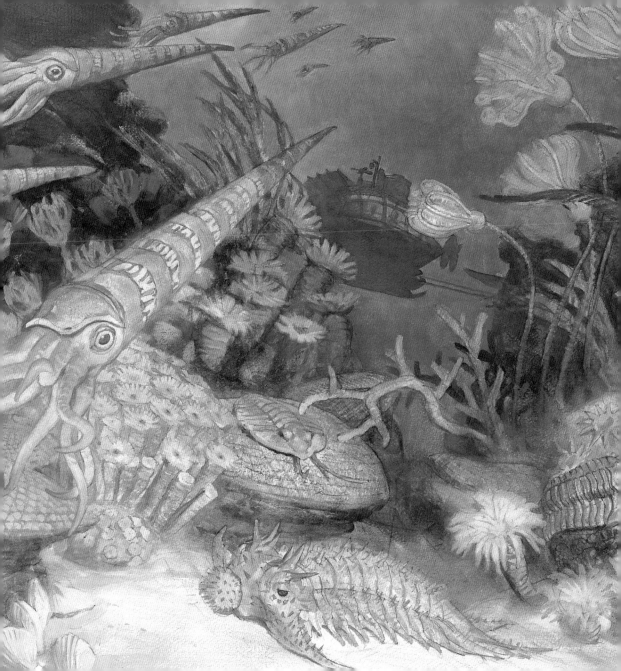

EXTINCTION
MAKES WAY
FOR INVENTION.

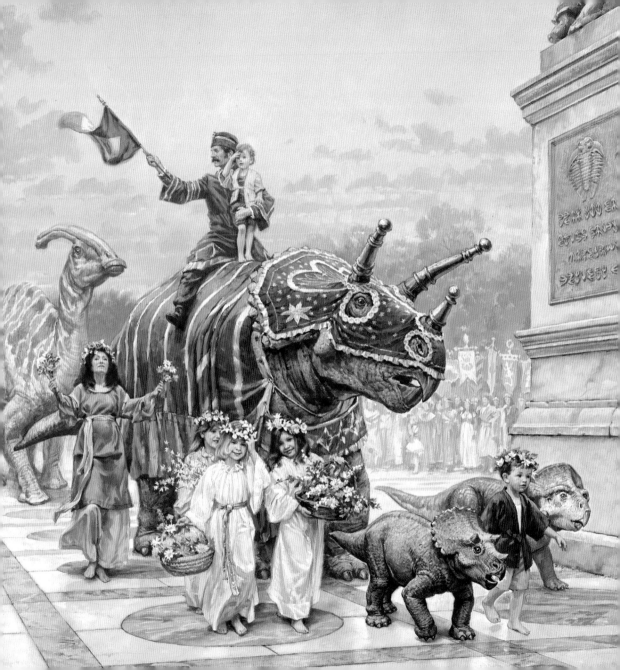

BREATHE DEEP,
SEEK PEACE.

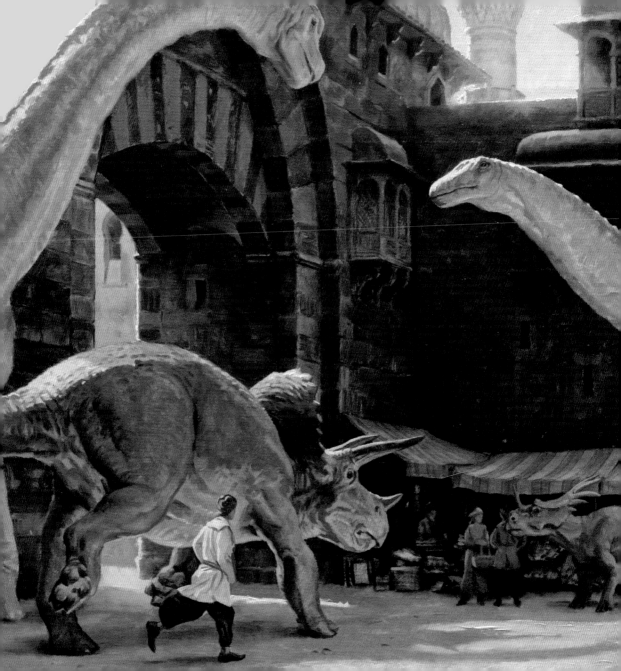

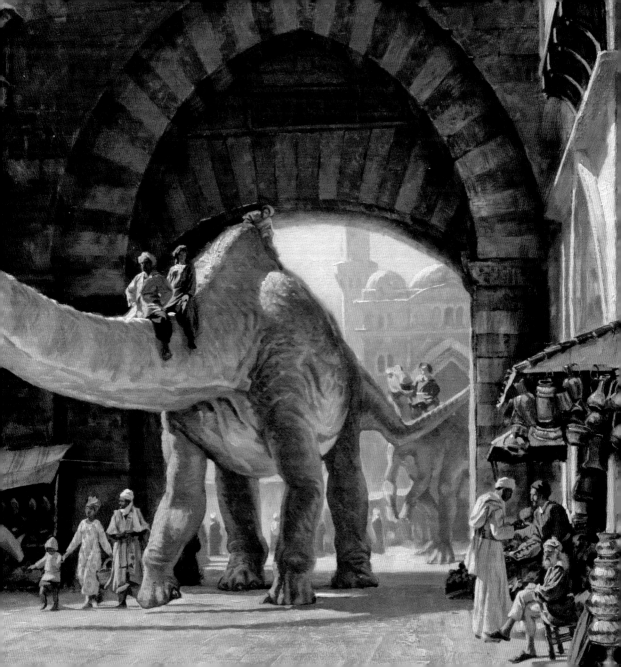

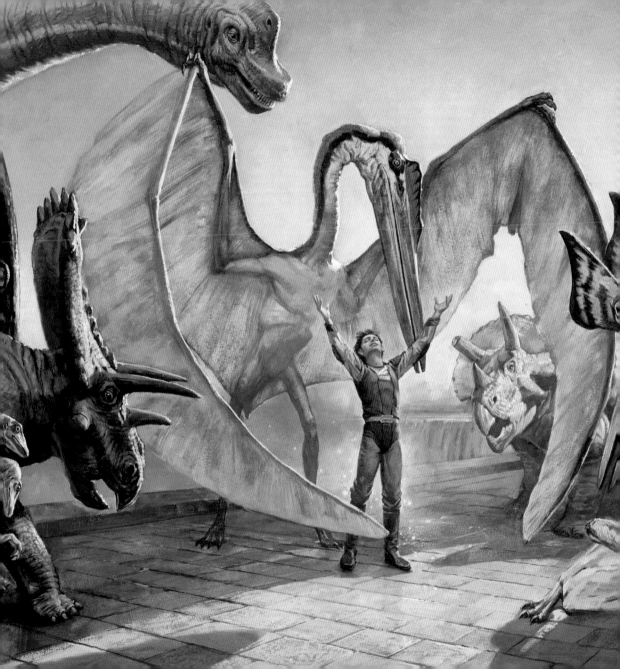

SURVIVAL
OF ALL
OR
NONE.

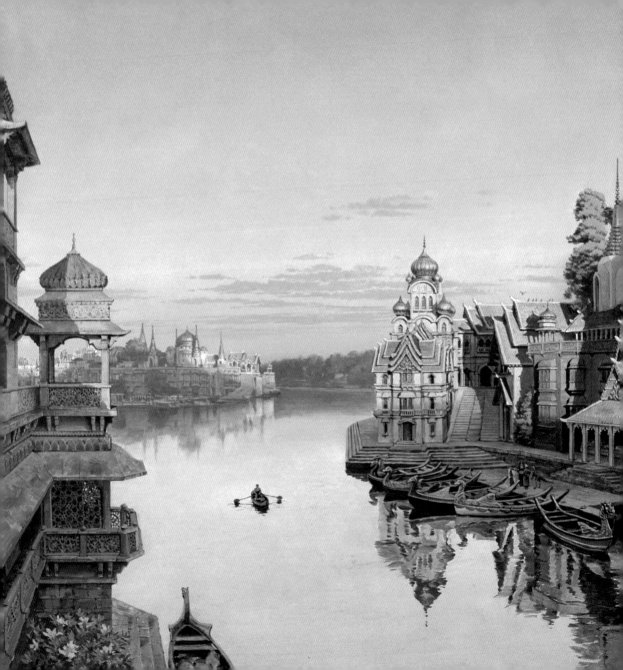

ONE
RAINDROP
RAISES
THE SEA.

WEAPONS ARE ENEMIES

EVEN TO

THEIR OWNERS.

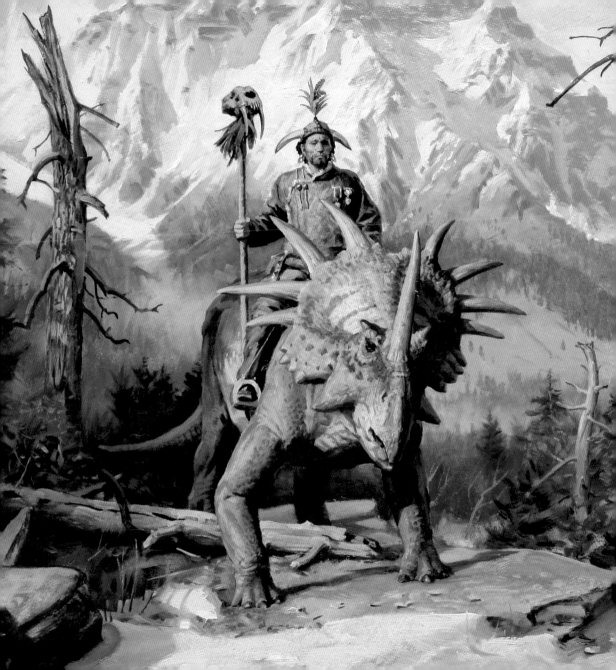

GIVE MORE,
TAKE LESS.

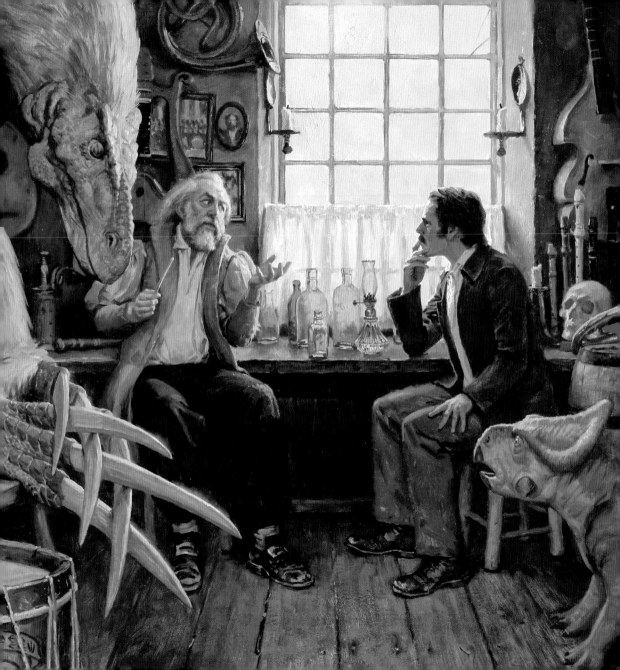

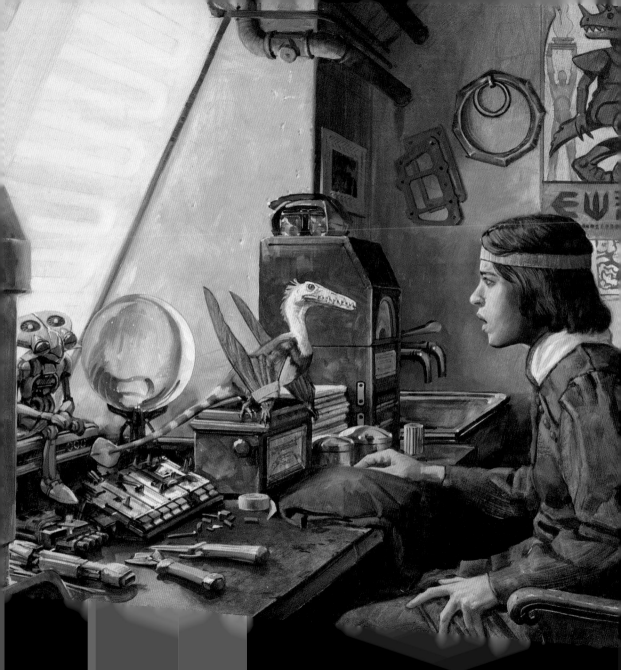

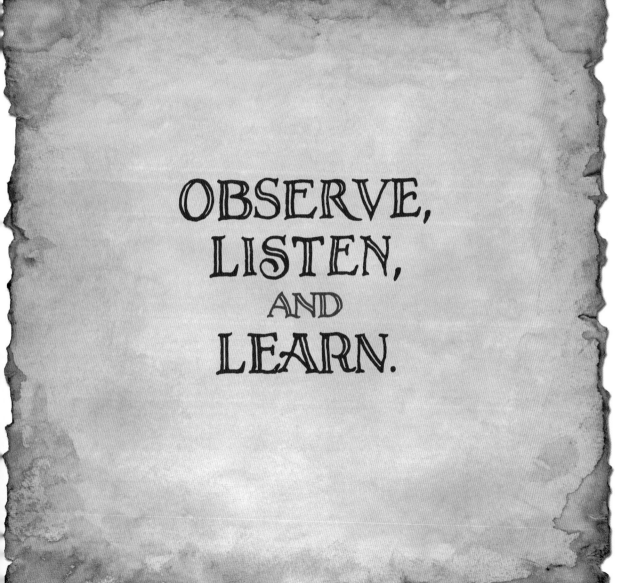

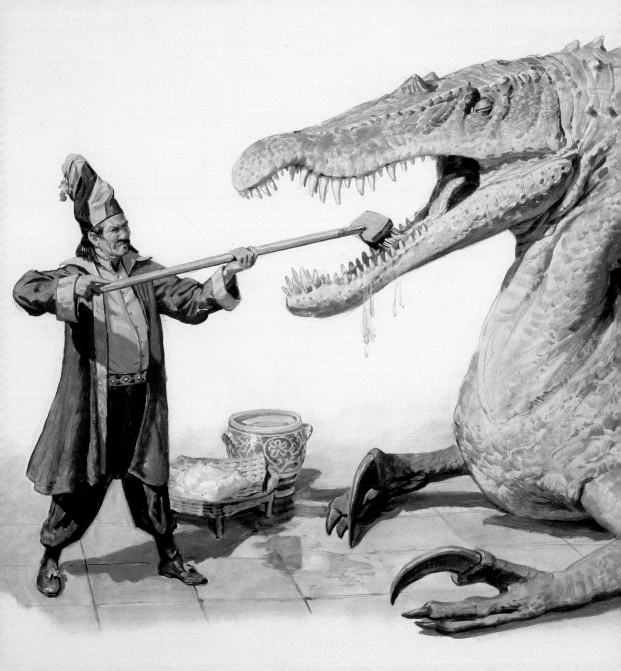

DO
ONE THING
AT A
TIME.

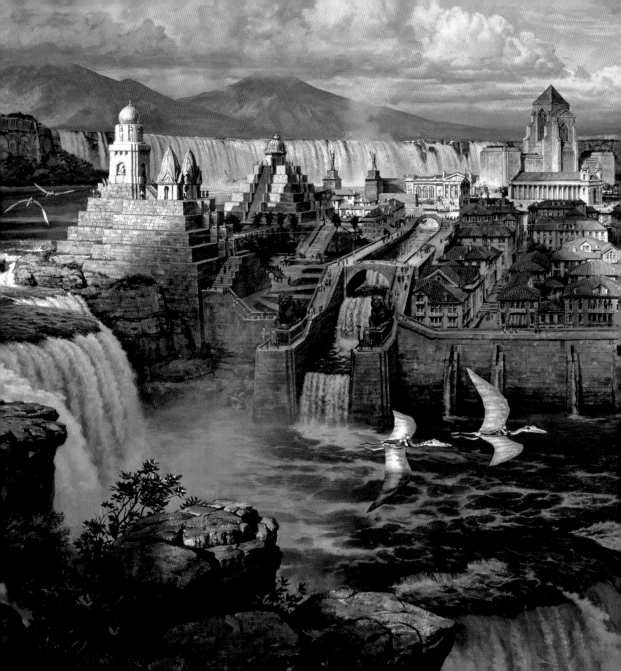

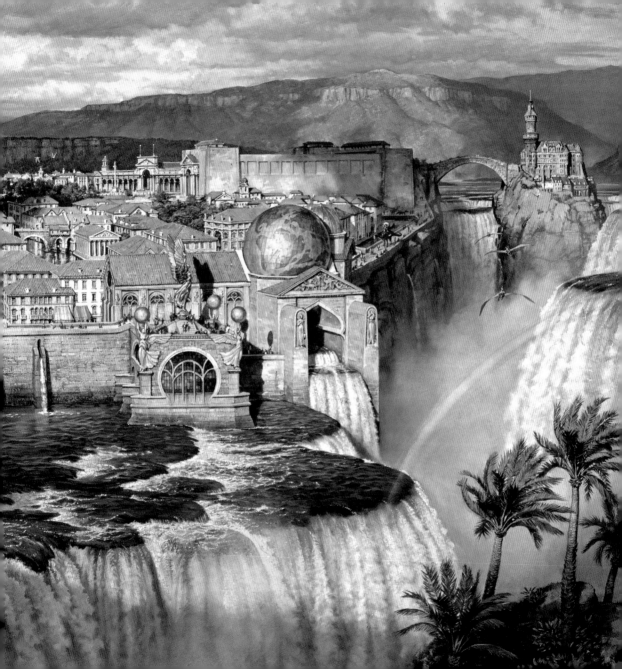

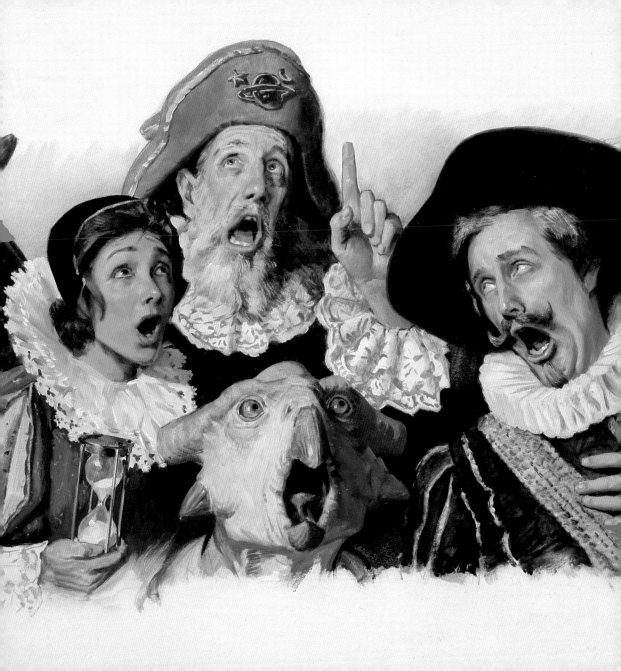

SING
EVERY DAY.

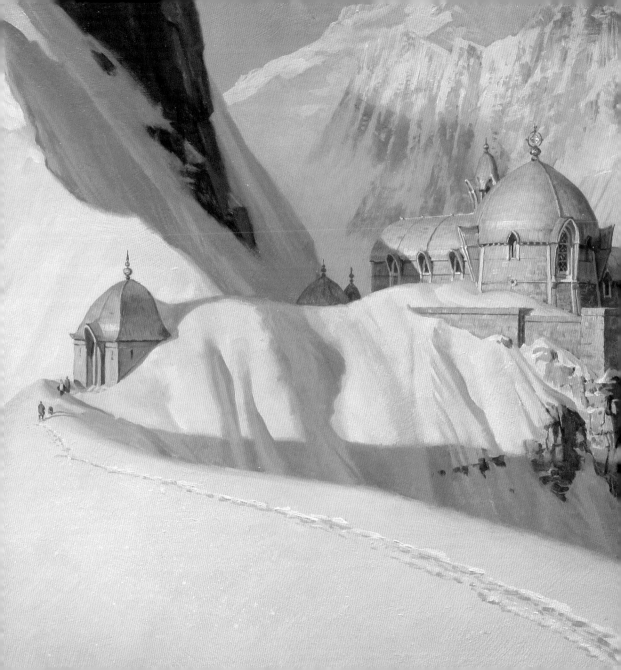

EXERCISE
IMAGINATION.

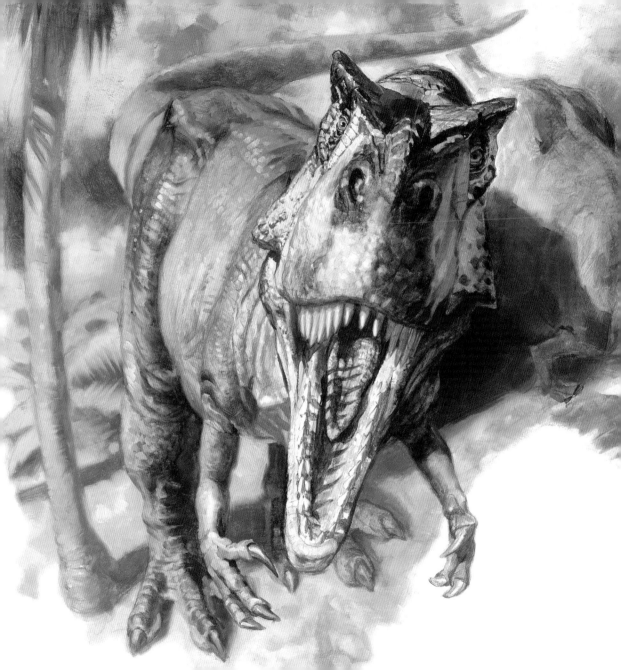

EAT TO LIVE,
DON'T
LIVE TO EAT.

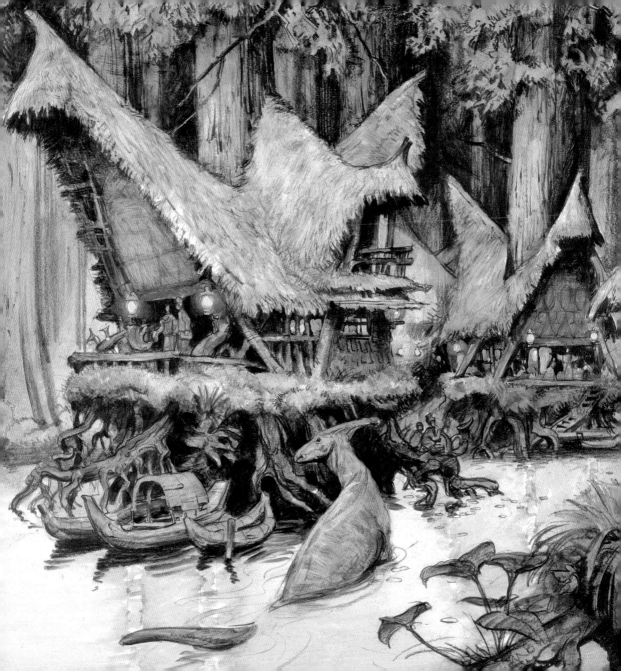

DON'T PEE IN THE BATH.

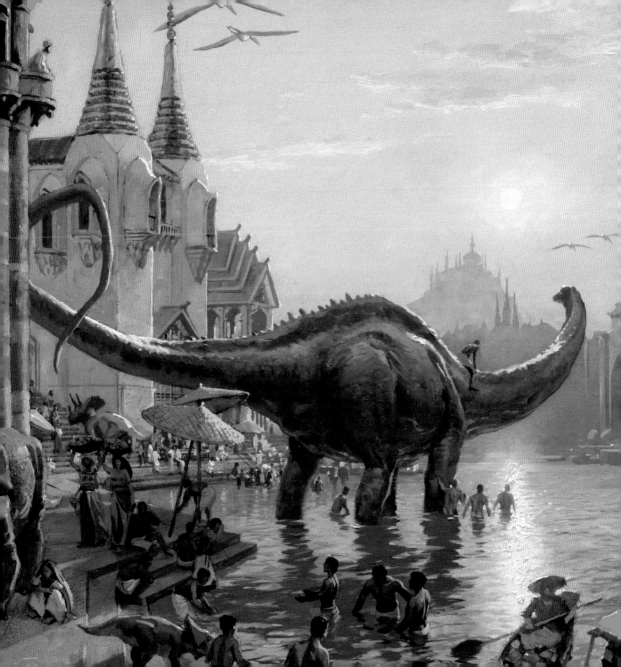

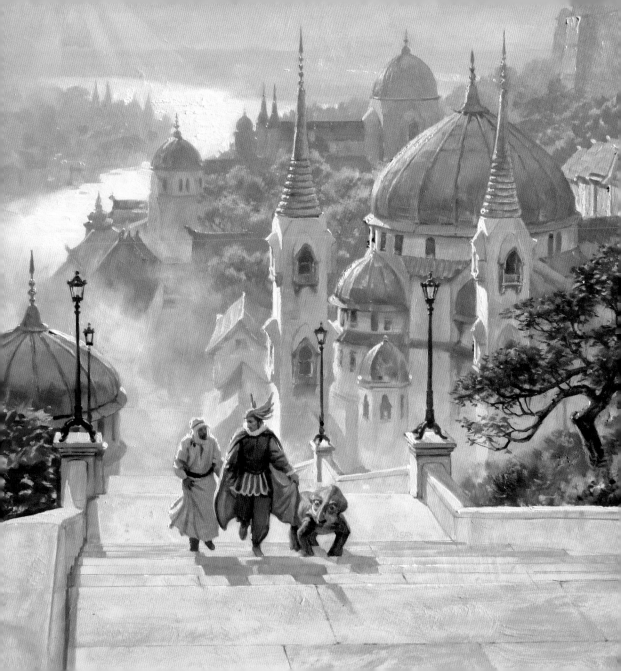

OUR WORLD
IS NOT CREATED
BY OUR EYES,
BUT BY
OUR MINDS.

For Saoirse and other hatchlings

Life Lessons from Dinosaurs

Andrews McMeel Publishing
a division of Andrews McMeel Universal
1130 Walnut Street, Kansas City, Missouri 64106

www.andrewsmcmeel.com

24 25 26 27 28 TEN 10 9 8 7 6 5 4 3 2 1

ISBN: 978-1-5248-9292-0

Library of Congress Control Number: 2024931865

Back cover photo illustration courtesy of National Museum Cardiff

Andrews McMeel Editorial and Production team:
Tamara Haus, Holly Swayne, Brianna Westervelt, Lucas Wetzel

ATTENTION: SCHOOLS AND BUSINESSES
Andrews McMeel books are available at quantity discounts with
bulk purchase for educational, business, or sales promotional use.
For information, please e-mail the Andrews McMeel Publishing
Special Sales Department: sales@amuniversal.com.